T0079917

KEW POCKETBOOKS

JAPANESE PLANTS

Introduction by Tony Hall and Martyn Rix

Curated by Lydia White

Kew Publishing

Royal Botanic Gardens, Kew

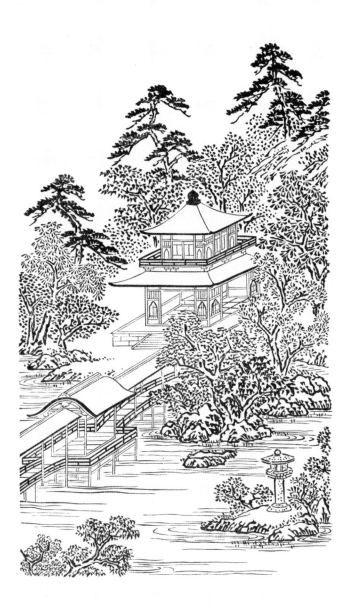

KEW HOLDS ONE OF THE LARGEST COLLECTIONS
of botanical literature, art and archive material in the
world. The library comprises 185,000 monographs and
rare books, around 150,000 pamphlets, 5,000 serial titles
and 25,000 maps. The Archives contain vast collections
relating to Kew's long history as a global centre of plant
information and a nationally important botanic garden
including 7 million letters, lists, field notebooks, diaries
and manuscript pages.

The Illustrations Collection comprises 200,000
watercolours, oils, prints and drawings, assembled over
the last 200 years, forming an exceptional visual record
of plants and fungi. Works include those of the great
masters of botanical illustration such as Ehret, Redouté
and the Bauer brothers, Thomas Duncanson, George
Bond and Walter Hood Fitch. Our special collections
include historic and contemporary originals prepared
for *Curtis's Botanical Magazine*, the work of Margaret
Meen, Thomas Baines, Margaret Mee, Joseph Hooker's
Indian sketches, Edouard Morren's bromeliad paintings,
'Company School' works commissioned from Indian
artists by Roxburgh, Wallich, Royle and others, and
the Marianne North Collection, housed in the gallery
named after her in Kew Gardens.

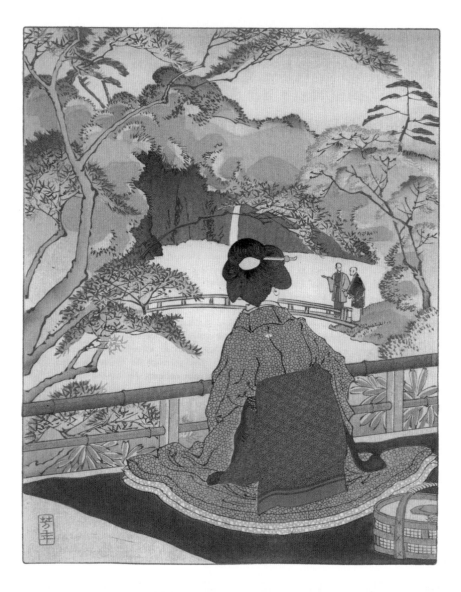

INTRODUCTION

THE INFLUENCE OF JAPAN ON HORTICULTURE
Gardening has been an art form in Japan for many centuries, with designs following the natural landscapes to create peaceful places to enjoy and meditate. The typical planting, based around the odd numbers three, five and seven, creates pleasing asymmetry and is now common practice in garden design worldwide.

Under its Sakoku policy, Japan was closed to the rest of the world for around 200 years until the mid-1800s. When its borders were opened, it attracted many western plant hunters. Plant hunters including Charles Maries, Carl Johann Maximowicz, Phillip Franz von Siebold (who all have plant names commemorated after them) explored Japan during the 19th and 20th centuries, drawn to the botanical riches of an estimated 7,000 native plant species, many endemic to the Japanese Islands. The famous Veitch nurseries in England funded trips to search, collect and introduce plants with good garden interest. Many of the plants collected were given the species name *japonica* or *japonicum*, meaning that they originated in Japan.

These collectors and others who travelled throughout Asia to find what was then new, exciting and unknown in the West, have added to the wonderful wealth of plants we grow and enrich our gardens with today.

Japan inspires with mountainsides filled with the amazing colours of azaleas and cherry blossom in spring, and maples whose fiery tones of oranges, reds and yellows are a spectacle in autumn. Bamboos, magnolias, camellias, rhododendrons, hydrangeas, wisteria and chrysanthemums are just a few of the many garden-worthy plants originally collected from Japan and now commonly grown in gardens around the world.

Many plants collected in Japan and brought into European gardens were originally considered exotic but are now common and widely grown. Hostas, also known by their Japanese name *giboshi*, are one example. These shade-tolerant perennials are grown mainly for their foliage but some species, like the Japanese native *Hosta sieboldiana*, are also grown for their flowers (see page 43). Japan is also home to many species of lily (*Lilium*), which range in colour from pure white to pink, red and orange and are often fragrant. Many cultivars have been bred, extending the range of colours and forms.

Japan is best known for its maples, particularly *Acer palmatum*, commonly known as the Japanese maple. Along with pines, they feature in most Japanese gardens. Both trees are also traditionally grown as bonsai, which translated literally means 'planted in a container'. They are miniaturised through pruning techniques that create dwarf specimen trees with both natural and stylised forms.

Kew has its own Japanese Landscape, formed of three gardens named Peace, Activity and Harmony. The Japanese Landscape was designed in 1996 around the Japanese Gateway, Chokushi-Mon (Gateway of the Imperial Messenger) originally created for the Japan–British Exhibition held in London in 1910. It is a near replica of the Gate of Nishi-Hongan-ji (Western Temple of the Original Vow) in Kyoto, Japan. Plants from Japan feature elsewhere in the Gardens as well, for instance in the azalea garden, which also grows Japanese maples. Many specimens in the Bamboo Garden are wild collected from Japan, and the collection dates back to the early 1800s, making it one of the oldest in the UK.

Tony Hall
Head of Gardens
Royal Botanic Gardens, Kew

JAPANESE BOTANICAL ART

Japan had a long tradition of botany and botanical painting before the arrival of European influence in the 18th century, and even after the Europeans brought western botany to Japan, Japanese style and taste continued to be important and to infuse their painting.

Initially the main influence came from China, particularly during the Nara period (AD 710–794), which was contemporary with the T'ang dynasty in China (ending c. AD 900), and during the early part of the following Chinese dynasties. Like early European illustrated herbals, the earliest Japanese paintings were sophisticated, artistic and decorative rather than designed to help identification.

Kew's library holds many important works on Japanese botany, particularly from the 19th and 20th centuries, including *Flora Japonica* (1830–75) by Phillip Franz von Siebold and Joseph Gerhard Zuccarini, which includes detailed botanical illustrations by the Japanese artist Keiga Kawahara. The Japanese plants introduced to the West by von Siebold became terribly fashionable, with many being illustrated in English botanical journals such as *Curtis's Botanical Magazine*, as well as continental equivalents such as the German *Gartenflora* and the Belgian *Flore de Serres et des Jardin de l'Europe*. Kew's library also contains a set of one of the most important Japanese herbals,

Honzō Zufu, a rare and valuable compendium of medicinal plants (find out more in *Kew Pocketbooks: Honzō Zufu*).

Many botanical artists worked in Japan during the late 19th and early 20th centuries. Perhaps the most original was the botanist and artist Tomitaro Makino, known as 'the father of Japanese taxonomic botany', who produced composite images for publication in his *Icones Florae Japonicae* (1900–1911). Similarly beautiful work was made by Chūsuke Suzaki for *Icones of the Essential Forest Trees of Hokkaido* (1920–33).

Botanical illustration continues to be a popular art form in Japan, as is shown by the many brilliant artists who bring their work to be exhibited at the Royal Horticultural Society in London. The aesthetic beauty of their work is unsurpassed, as was demonstrated by the paintings shown in the recent *Flora Japonica* exhibition at Kew's Shirley Sherwood Gallery of Botanical Art. This was organised by botanical artist Masumi Yamanaka, who has been based at Kew for the last 18 years. Her huge painting of the miracle pine (see page 91) which survived the great tsunami of 2011 commemorates this dreadful disaster – but is also a monument to the resilience of nature.

Martyn Rix
Editor, *Curtis's Botanical Magazine*

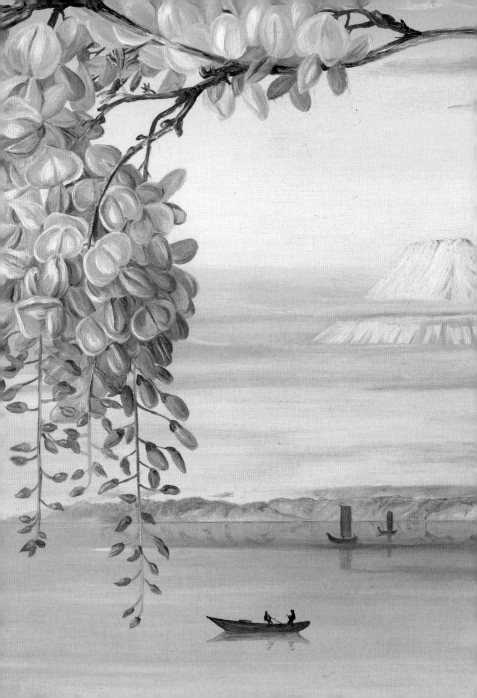

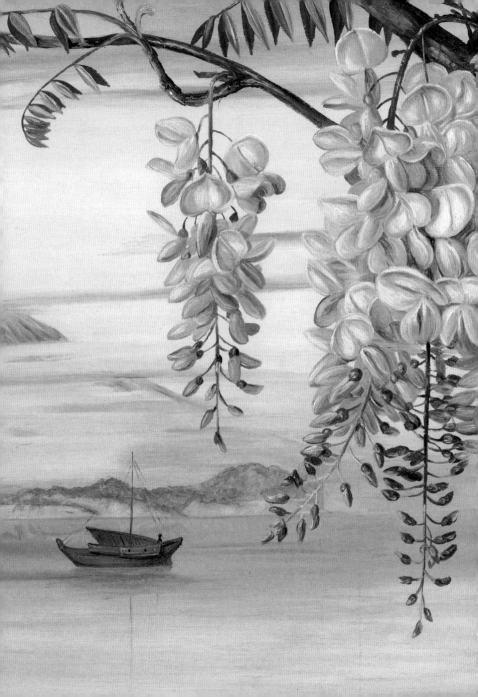

Acer species

maple

from Yokohama Ueki Kabushiki Kaisha *Catalogue of the Yokohama Nursery Co., Ltd.*, 1907

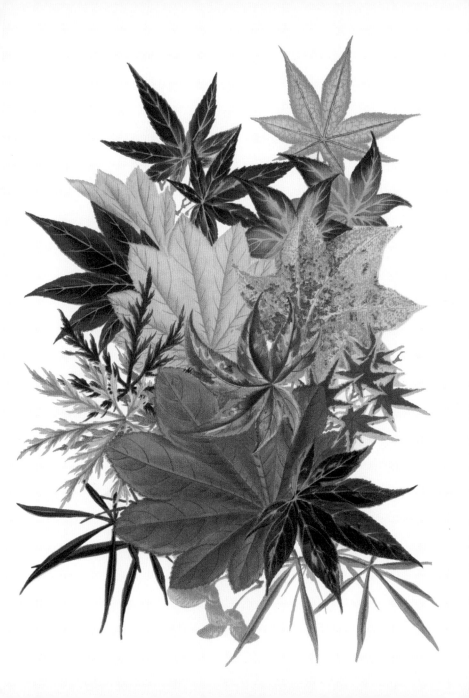

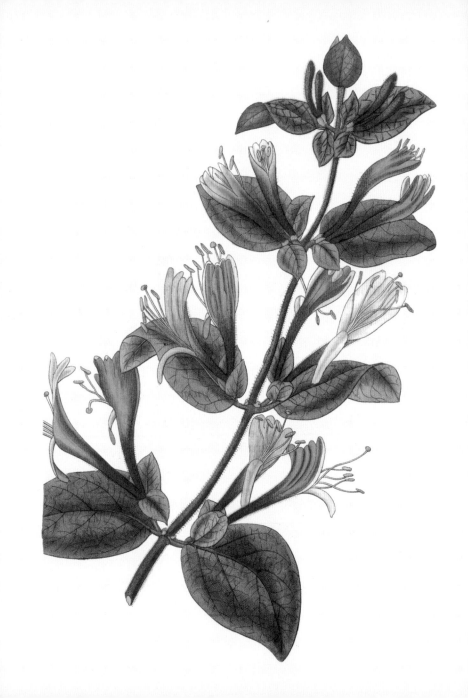

Lonicera japonica

Japanese honeysuckle, sui-kazura

––––––––––

by S. M. Curtis
from *Curtis's Botanical Magazine*, 1834

Laeliocattleya ur.
No. 106 'Oyamazaki'

by Zuigetsu Ikeda
from Stephen Kirby, Toshikazu Doi and Toru Otsuka
*Rankafu Orchid Print Album: Masterpieces of Japanese
Woodblock Prints of Orchids,* 2018

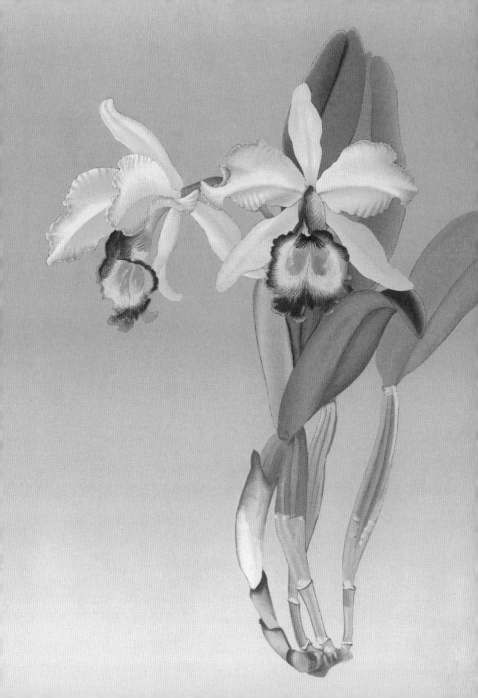

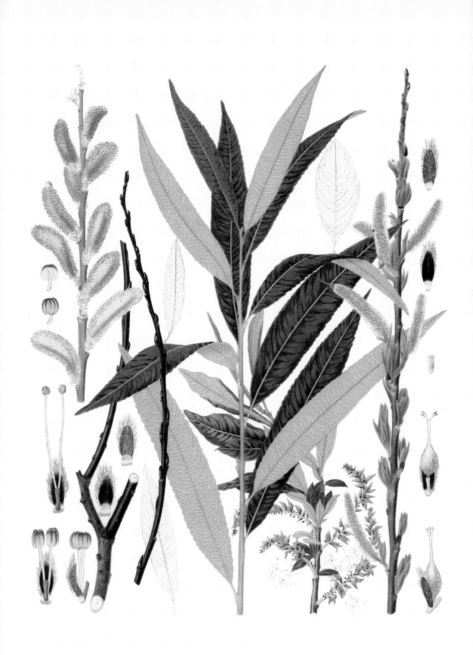

Salix udensis

Japanese fantail willow

―――――――

by Chūsuke Suzaki
from Miyabe Kingo and Kudō Yūshun
Icones of the Essential Forest Trees of Hokkaido, 1920-3

Paeonia x *suffruticosa* 'Hiryo'

tree peony

from Yokohama Ueki Kabushiki Kaisha
*Paeonia Moutan: a collection of
50 choice varieties*, c. 1900

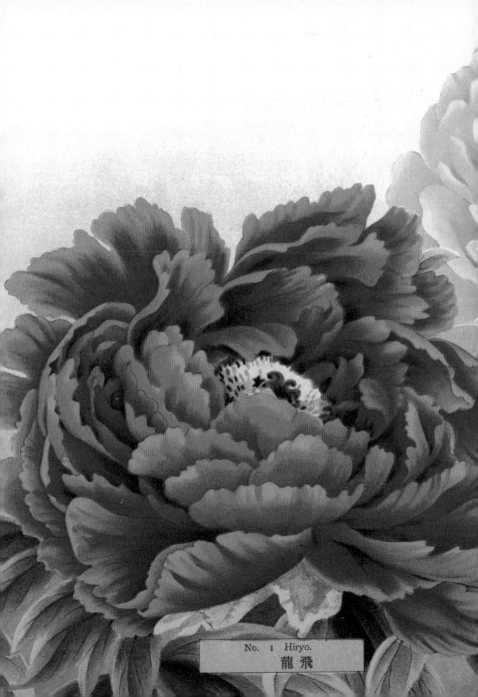

No. 1 Hiryo.
飛龍

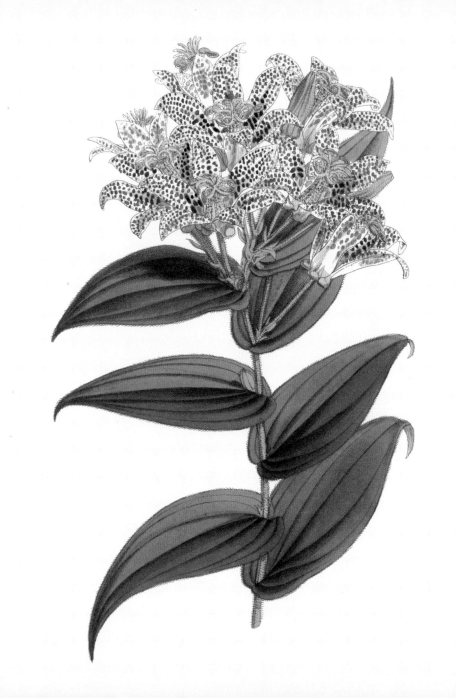

Tricyrtis hirta

toad lily, Japanese toad lily, hototogisu

———————

by Walter Hood Fitch
from *Curtis's Botanical Magazine*, 1863

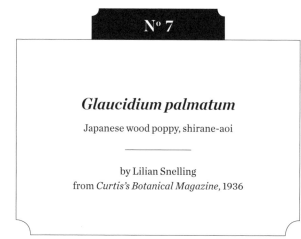

Glaucidium palmatum

Japanese wood poppy, shirane-aoi

by Lilian Snelling
from *Curtis's Botanical Magazine,* 1936

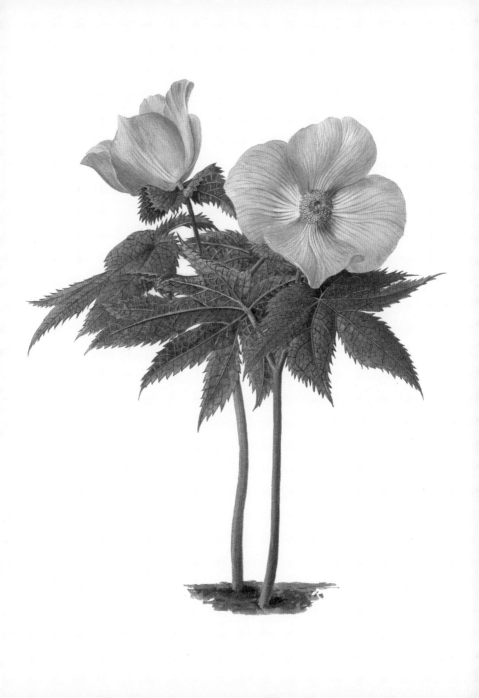

Dryopteris erythrosora

Japanese shield fern, autumn fern,
copper shield fern, beni-shida

———————

by Asuka Hishiki
from Kew Collection, 2016

N⁰ 9

Camellia japonica

common camellia, Japanese camellia,
rose of winter, 'Festiva del Grande', yabu-tsubaki

───────────

from Louis van Houtte
Flore des serres et des jardins de l'Europe, 1874

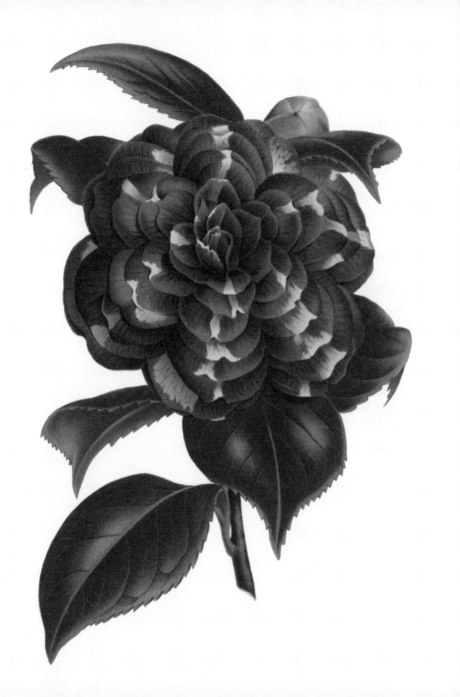

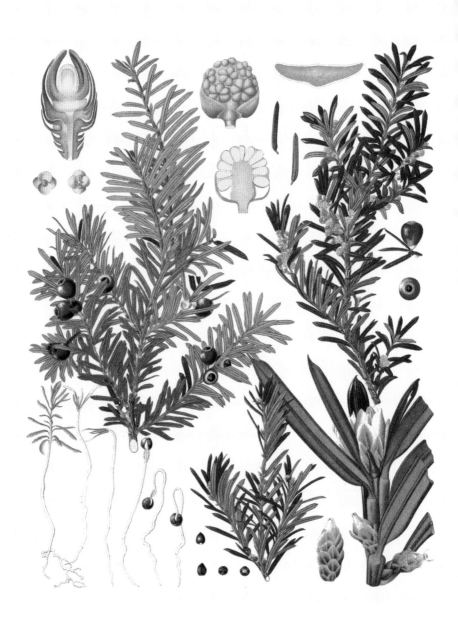

Taxus cuspidata

Japanese yew, spreading yew

by Chūsuke Suzaki
from Miyabe Kingo and Kudō Yūshun
Icones of the Essential Forest Trees of Hokkaido, 1920-3

Rhododendron indicum

indoor azalea

from Kazumasa Ogawa
Some Japanese Flowers, c. 1895

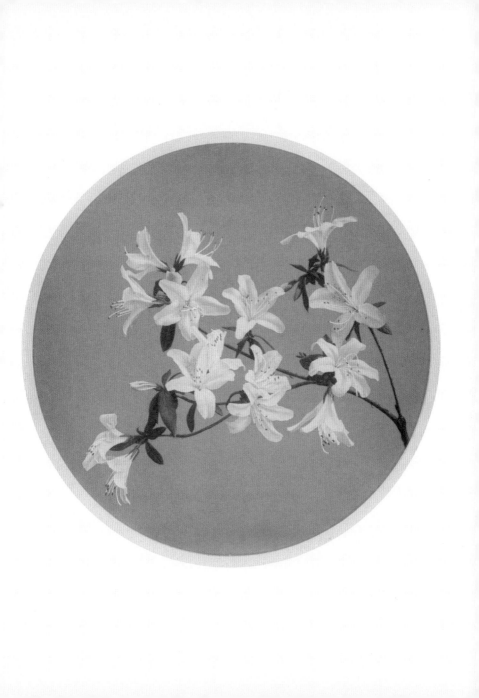

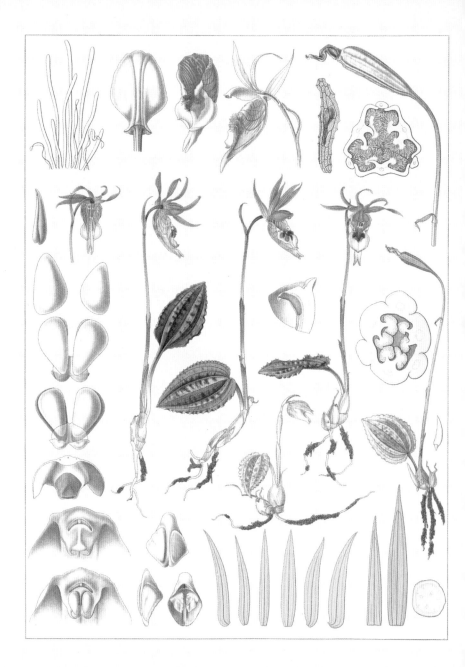

Calypso bulbosa var. *speciosa*

bog orchid, calypso orchid, hotei-ran

by Tomitaro Makino
from *Icones Florae Japonicae*, 1900-11

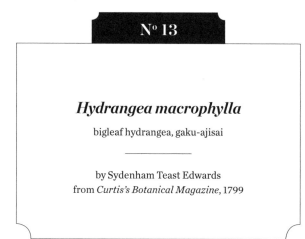

N⁰ 13

Hydrangea macrophylla

bigleaf hydrangea, gaku-ajisai

by Sydenham Teast Edwards
from *Curtis's Botanical Magazine*, 1799

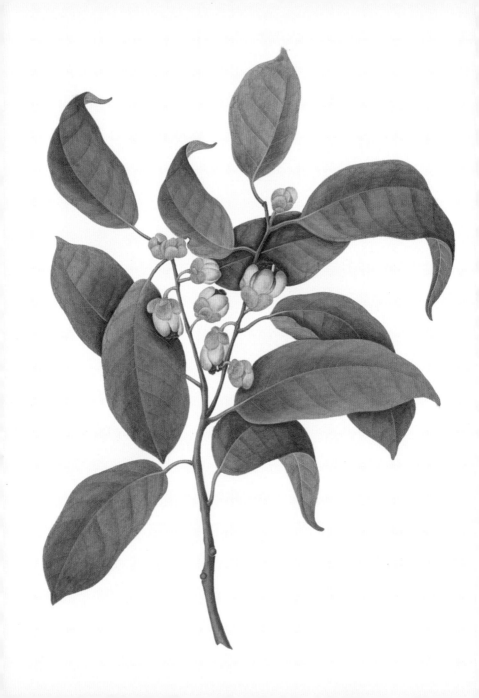

N° 14

Kadsura japonica

Japanese kadsura, kadsura vine

———————

by unknown artist
from the General John Eyre Collection, Kew, c.1850

Iris ensata 'Senjo-no-hora' and 'Ōyodo'

Japanese iris

from Yokohama Ueki Kabushiki Kaisha
Iris Kaempferi: 18 best var, c.1900

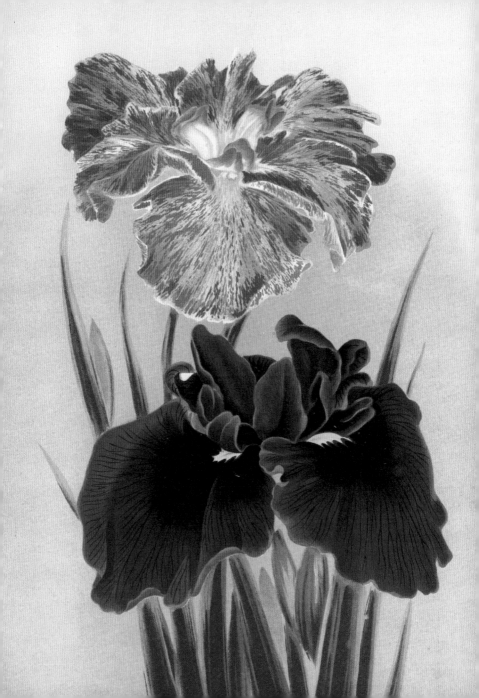

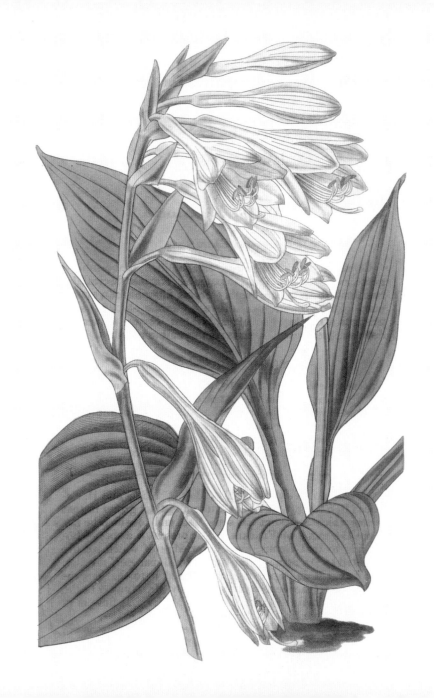

Hosta sieboldii

Siebold's plantain lily,
small-leaved plantain lily

———————

by Walter Hood Fitch
from *Curtis's Botanical Magazine*, 1839

Chrysanthemum x *morifolium*

Japanese chrysanthemum

by E. Amberg
from Ludwig Wittmack *Gartenflora*, 1897

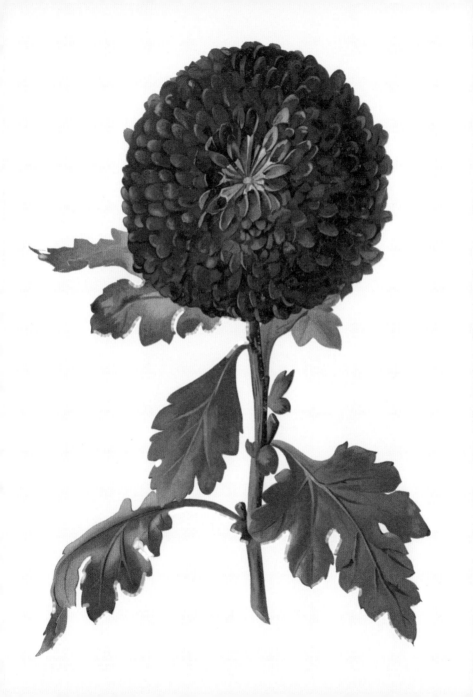

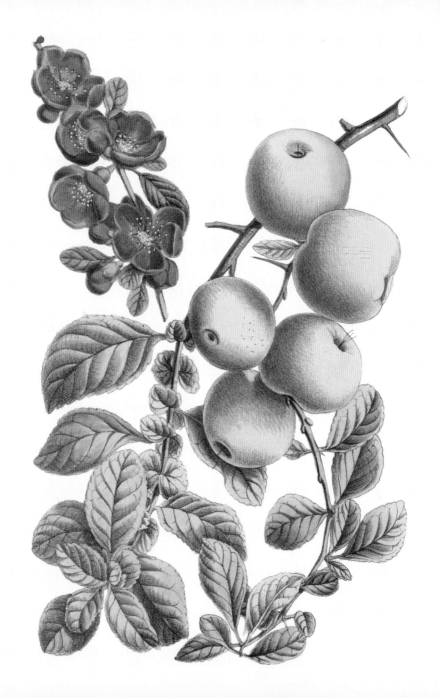

Chaenomeles japonica

Japanese quince, kusa-boke

———————

by Anne Henslow Barnard
from *Curtis's Botanical Magazine*, 1884

Aralia elata

Japanese angelica tree, angelica tree

by Chūsuke Suzaki
from Miyabe Kingo and Kudō Yūshun
Icones of the Essential Forest Trees of Hokkaido, 1920-3

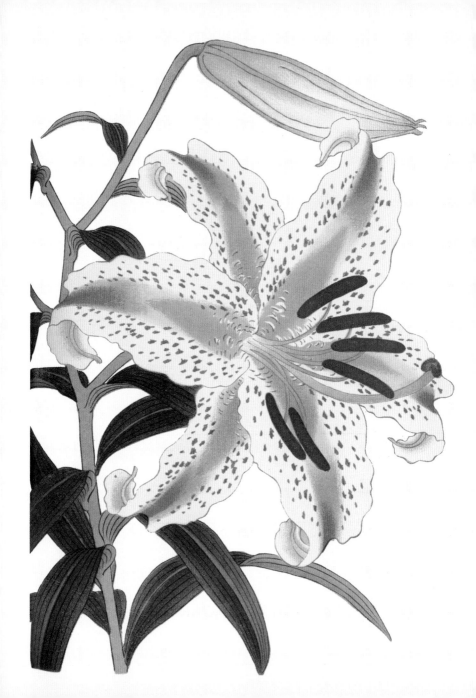

Lilium auratum 'Pictum'

goldband lily, yama-yuri

from Yokohama Ueki Kabushiki Kaisha
Lilies of Japan, 1899

Pinus parviflora

Japanese white pine, five-needle pine

by unknown artist
commissioned by Robert Fortune,
Kew Collection, c.1850

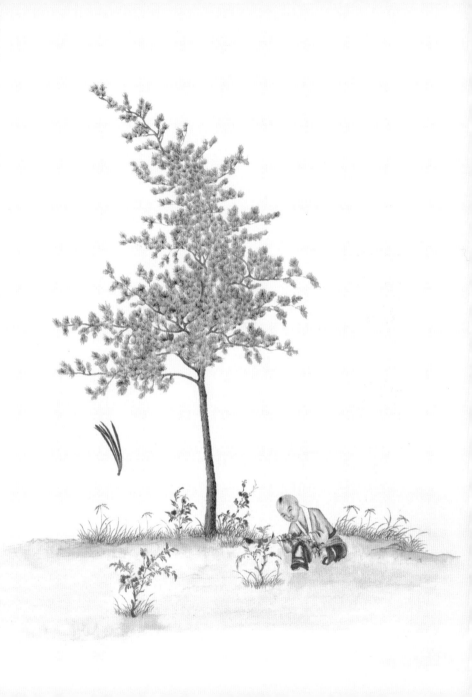

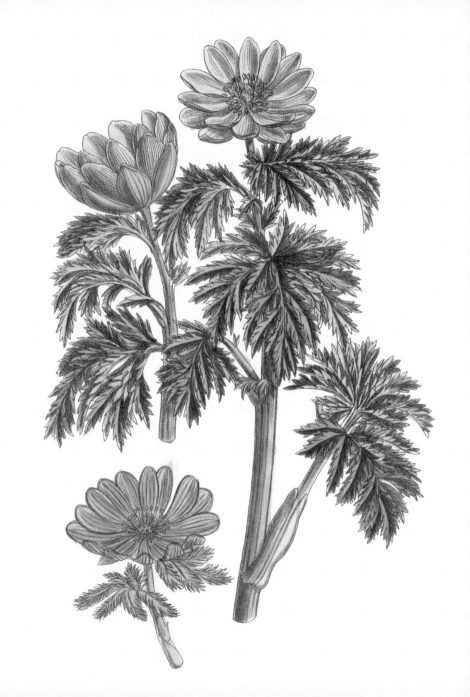

Adonis amurensis

Amur adonis, fukujusō

by Matilda Smith
from *Curtis's Botanical Magazine,* 1896

Prunus serrulata f. *formosissima* 'Benitora-no-o'

Japanese cherry

from Manabu Miyoshi *Ōka Zufu*, 1921

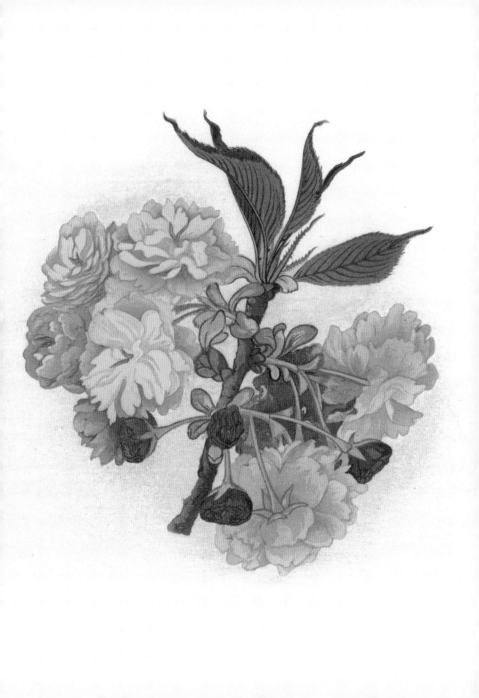

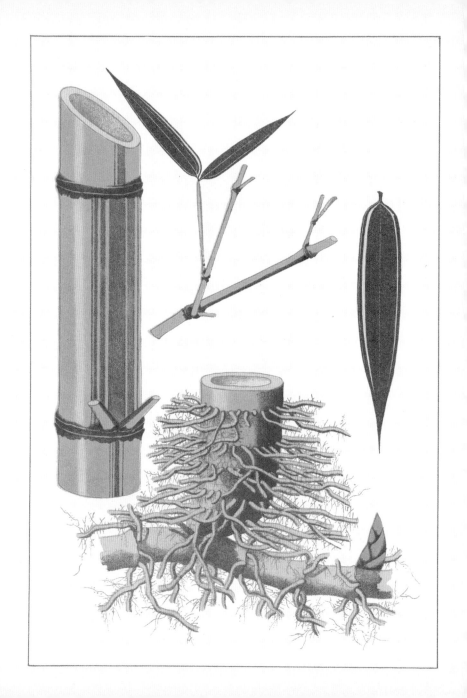

N⁰ 24

Phyllostachys reticulata

giant timber bamboo

from Isuke Tsuboi *Illustrations of the Japanese species of bamboo*, 1916

Acer japonicum

Japanese maple, hauchiwa-kaede

by Chūsuke Suzaki
from Miyabe Kingo and Kudō Yūshun
Icones of the Essential Forest Trees of Hokkaido, 1920-3

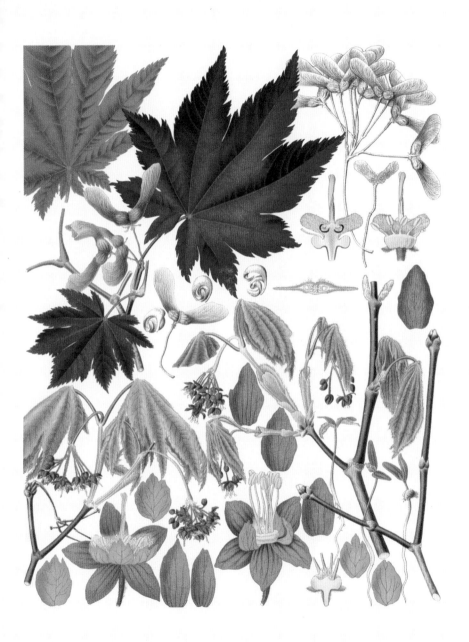

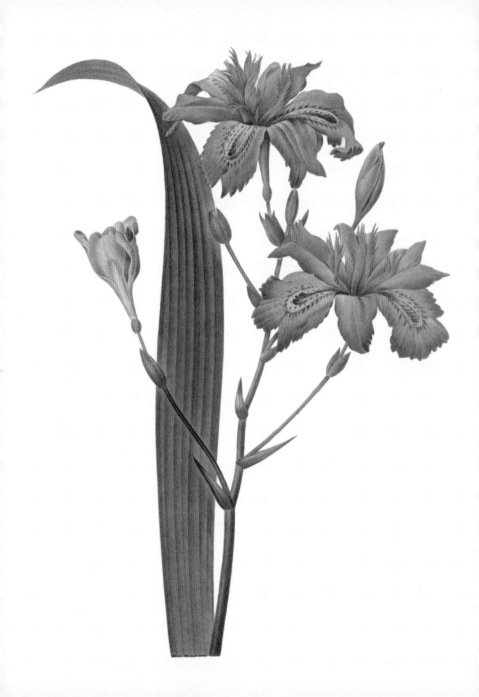

Iris japonica

fringed iris, shaga

by Pierre Joseph Redouté
from Pierre Joseph Redouté
Choix des plus belles fleurs, 1827-32

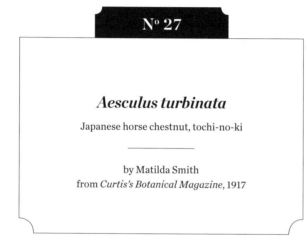

Aesculus turbinata

Japanese horse chestnut, tochi-no-ki

by Matilda Smith
from *Curtis's Botanical Magazine*, 1917

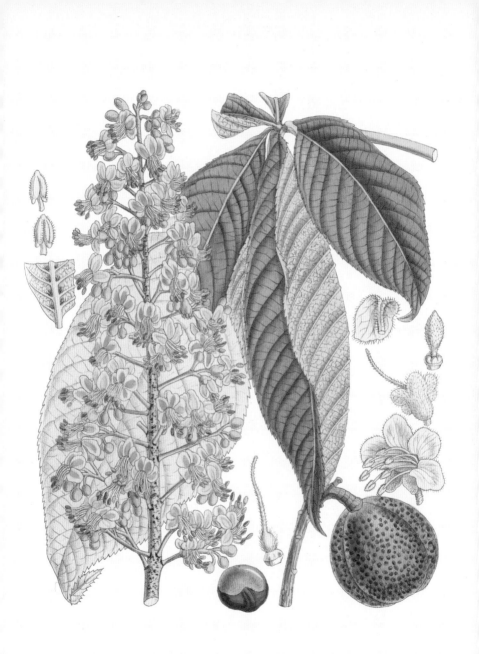

Nº 28

Study of Japanese chrysanthemums and dwarfed pine

by Marianne North
from Marianne North Collection, Kew, 1880

Rhododendron quinquefolium

cork azalea, five-leaved rhododendron

from Yokohama Ueki Kabushiki Kaisha
Catalogue of the Yokohama Nursery Co., Ltd., 1907

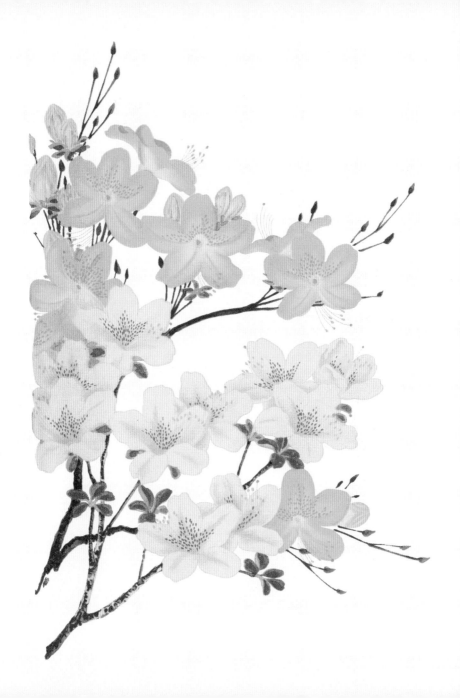

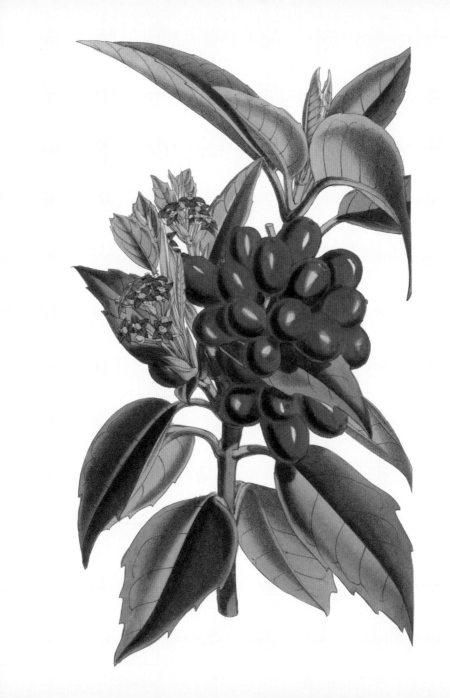

Aucuba japonica

Japanese laurel, spotted laurel

by Walter Hood Fitch
from *Curtis's Botanical Magazine,* 1865

Cymbidium Okagami
'Oyamazaki'

by Zuigetsu Ikeda
from Stephen Kirby, Toshikazu Doi and Toru Otsuka
*Rankafu Orchid Print Album: Masterpieces of Japanese
Woodblock Prints of Orchids*, 2018

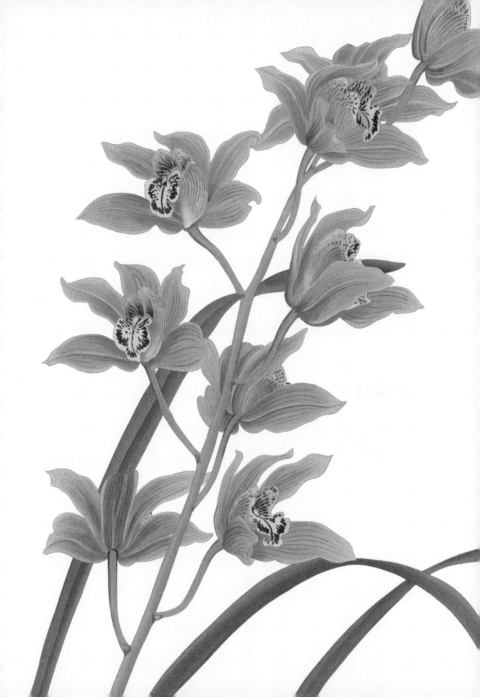

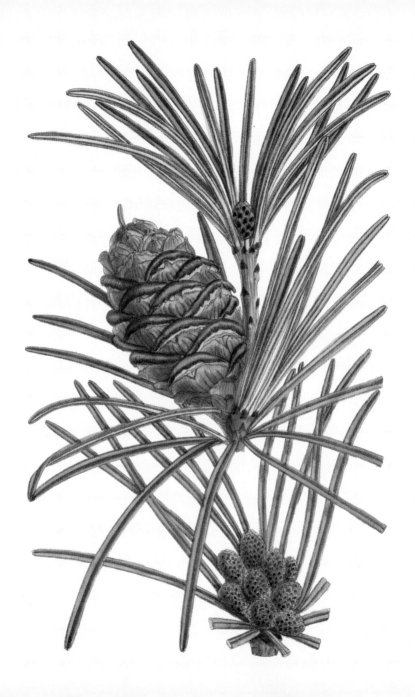

Sciadopitys verticillata

umbrella pine, Japanese umbrella pine

by Matilda Smith
from *Curtis's Botanical Magazine,* 1905

Lilium lancifolium 'Splendens'

tiger lily, devil lily, oniyuri

from Yokohama Ueki Kabushiki Kaisha
Lilies of Japan, 1899

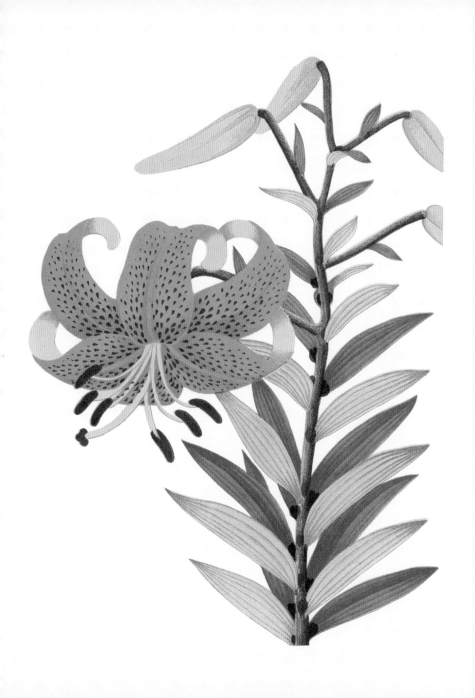

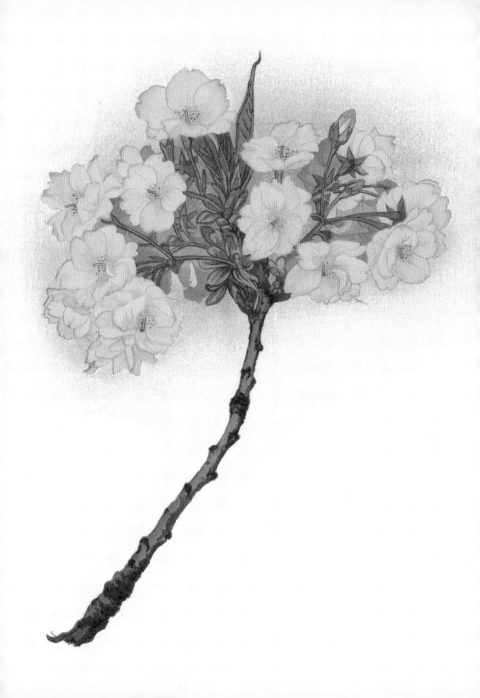

Prunus serrulata f. *multipetala*
'Na-jimasakura'

Japanese cherry

from Manabu Miyoshi *Ōka Zufu*, 1921

Betula maximowicziana

monarch birch

by Chūsuke Suzaki
from Miyabe Kingo and Kudō Yūshun
Icones of the Essential Forest Trees of Hokkaido, 1920-3

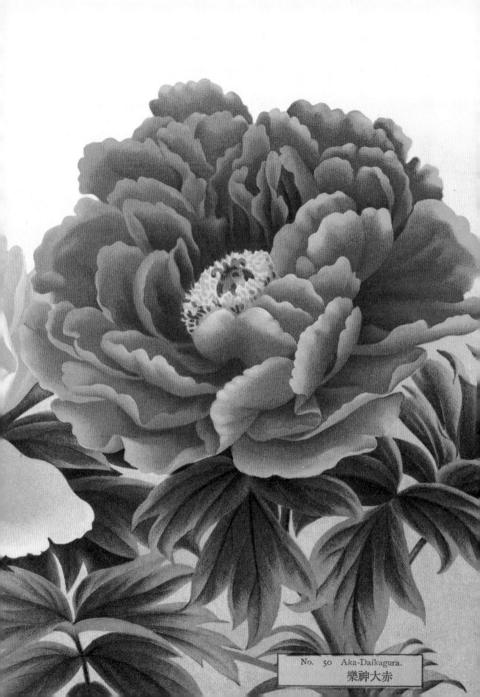

No. 50 Aka-Daikagura.

樂神大赤

Paeonia x *suffruticosa* 'Aka-Daikagura'

tree peony

from Yokohama Ueki Kabushiki Kaisha
*Paeonia Moutan: a collection of
50 choice varieties*, c. 1900

Pleioblastus fortunei

dwarf whitestripe, golden bamboo,
running bamboo

from Isuke Tsuboi *Illustrations of the
Japanese species of bamboo*, 1916

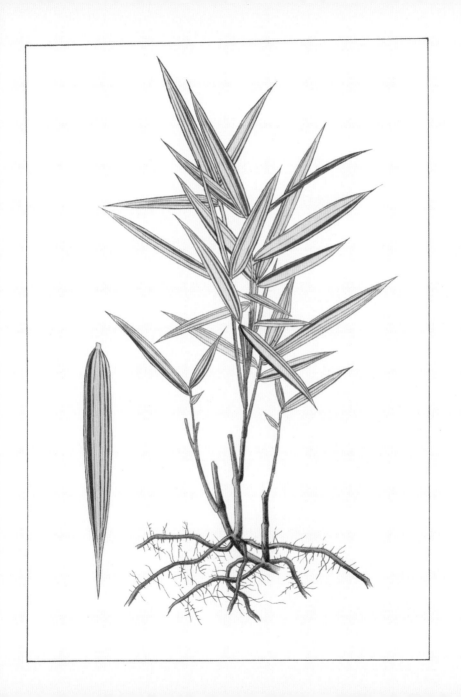

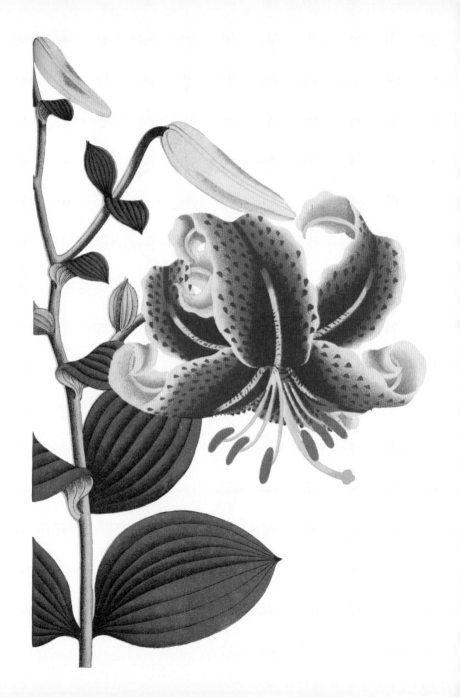

Lilium speciosum 'Melpomene'

Japanese lily

from Yokohama Ueki Kabushiki Kaisha
Lilies of Japan, 1899

Magnolia kobus

northern Japanese magnolia, kobus magnolia

———————

by Chūsuke Suzaki
from Miyabe Kingo and Kudō Yūshun
Icones of the Essential Forest Trees of Hokkaido, 1920-3

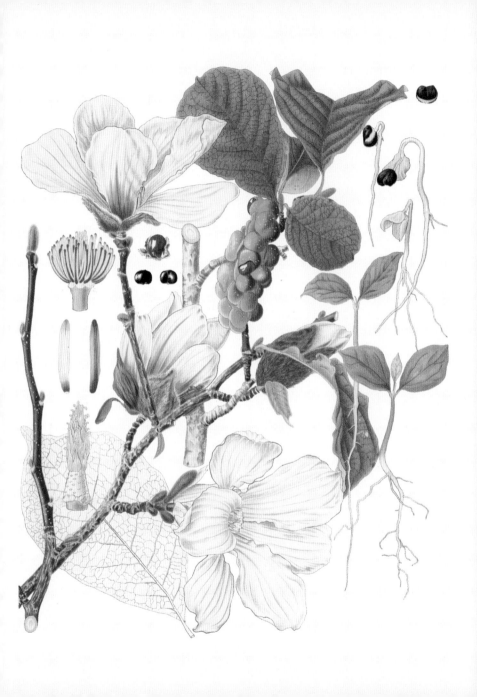

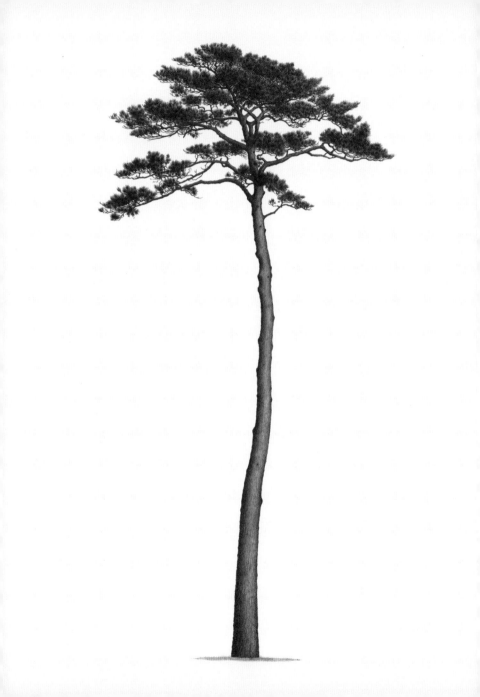

N⁰ 40

Pinus x *densithunbergii*

miracle pine

by Masumi Yamanaka, 2016

ILLUSTRATION SOURCES

Books and Journals

College of Science, Imperial University of Tokyo. (1900-11). *Icones Florae Japonicae*. The University of Tokyo, Japan.

Conder, Josiah. (1891). *The Flowers of Japan and The Art of Floral Arrangement*. Hakubunsha, Ginza and also Kelly and Walsh, Limited, Yokohama, Shanghai, Hong Kong, and Singapore.

Conder, Josiah. (1893). *Landscape Gardening in Japan*. Kelly and Walsh, Tokyo.

Curtis, W. (1799). *Hydrangea hortensis*. *Curtis's Botanical Magazine*. Volume 13, t. 438.

Hooker, J. D. (1896). *Adonis amurensis*. *Curtis's Botanical Magazine*. Volume 122, t. 7490.

Hooker, J. D. (1865). *Aucuba japonica*. *Curtis's Botanical Magazine*. Volume 91, t. 5512.

Hooker, J. D. (1884). *Pyrus maulei*. *Curtis's Botanical Magazine*. Volume 110, t. 6780.

Hooker, W. J. (1839). *Funkia sieboldiana*. *Curtis's Botanical Magazine*. Volume 65, t. 3663.

Hooker, W. J. (1834). *Lonicera japonica*. *Curtis's Botanical Magazine*. Volume 61, t. 3316.

Hooker, W. J. (1863). *Tricyrtis hirta*. *Curtis's Botanical Magazine*. Volume 89, t. 5355.

Kingo, Miyabe and Yūshun, Kudō. (1920-3). *Icones of the Essential Forest Trees of Hokkaido*. Hokkaido Government, Japan.

Kirby, Stephen, Doi, Toshikazu and Otsuka, Toru. (2018). *Rankafu Orchid Print Album: Masterpieces of Japanese Woodblock Prints of Orchids*, 2018. Royal Botanic Gardens, Kew.

Miyoshi, Manabu. (1921). *Ōka Zufu*. Unsōdō, Tokyo.

Ogawa, Kazumasa. (c. 1895). *Some Japanese Flowers*. Kazumasa Ogawa, Tokyo.

Prain, D. (1917). *Aesculus turbinata*. *Curtis's Botanical Magazine*, Volume 143, t. 8713.

Redouté, Pierre Joseph. (1827-32). *Choix des plus belles fleurs*. Ernest Panckoucke, Paris.

Thiselton-Dyer, W. T. (1905). *Sciadopitys verticillata*. *Curtis's Botanical Magazine*. Volume 131, t. 8050.

Tsuboi, Isuke. (1916). *Illustrations of the Japanese species of bamboo*. Hatsubaijo Maruzen Kabushiki Kaisha, Tokyo.

Turrill, W. B. (1936). *Glaucidium palmatum*. *Curtis's Botanical Magazine*. Volume 159, t. 9432.

van Houtte, Louis. (1874). *Camellia japonica. Flore des serres et des jardins de l'Europe*. Volume 29, p. 116.

Wittmack, Ludwig. (1897). *Chrysanthemum indicum. Gartenflora.* Volume 46, t. 1444.

Yokohama Ueki Kabushiki Kaisha. (1907). *Catalogue of the Yokohama Nursery Co., Ltd.* Yokohama Nursery Co., Yokohama.

Yokohama Ueki Kabushiki Kaisha. (c.1900). *Iris Kaempferi: 18 best var.* Yokohama Nursery Co., Yokohama.

Yokohama Ueki Kabushiki Kaisha. (1899). *Lilies of Japan.* Yokohama Nursery Co., Yokohama.

Yokohama Ueki Kabushiki Kaisha. (c. 1900). *Paeonia Moutan: a collection of 50 choice varieties.* Yokohama Nursery Co., Yokohama.

Art Collections

General John Eyre (1791–1865). Collection comprising 190 watercolours by Eyre during his time stationed in Hong Kong as the Commander of the British Forces in China, 1847-51.

Robert Fortune (1812–80). Collection made by Scottish plant collector who travelled extensively in the Far East, often for the Horticultural Society of London, working in China and Japan from 1843 until 1862.

Marianne North (1830–90). Comprising over 800 oils on paper, showing plants in their natural settings, painted by North, who recorded the world's flora during travels from 1871 to 1885, with visits to 16 countries in 5 continents. The main collection is on display in the Marianne North Gallery at Kew Gardens, bequeathed by North and built according to her instructions, first opened in 1882.

Sir Harry Parkes (1828–85). Held in Kew's Economic Botany Collection, the Parkes Collection contains 111 washi (handmade Japanese paper) sheets and 17 objects made from washi. Collected by Parkes as the British minister in Tokyo, for his 1871 report on paper manufacture in Japan.

ACKNOWLEDGEMENTS

Kew Publishing would like to thank the following for their help with this publication: Kew's Head of Gardens Tony Hall, editor of *Curtis's Botanical Magazine* Martyn Rix; in Kew's Library, Art and Archives Fiona Ainsworth, Julia Buckley, Lynn Parker, Craig Brough and Anne Marshall; for digitisation work, Paul Little; for permission to use their illustrations, Asuka Hishiki (page 26), Steve Kirby (pages 17, 73), and Masumi Yamanaka (page 90).

FURTHER READING

Abe, Naoko. (2019). *'Cherry' Ingram: the Englishman who saved Japan's blossoms*. Chatto & Windus, London.

Broadbent Casserley, Nancy. (2013). *Washi: the art of Japanese paper*. Royal Botanic Gardens, Kew.

Kew Pocketbooks. (2020). *Honzō Zufu*. Royal Botanic Gardens, Kew.

Kirby, Stephen, Doi, Toshikazu and Otsuka, Toru. (2018). *Rankafu Orchid Print Album: Masterpieces of Japanese Woodblock Prints of Orchids*. Royal Botanic Gardens, Kew.

North, Marianne and Mills, Christopher. (2018). *Marianne North: The Kew Collection*. Royal Botanic Gardens, Kew.

Payne, Michelle. (2016). *Marianne North: A Very Intrepid Painter*, revised edition. Royal Botanic Gardens, Kew.

Siebold, Philipp Franz von, Miquel, Friedrich Anton Wilhelm, Zuccarini, Joseph Gerhard. (1835-70). *Flora Japonica*. Lugduni Batavorum.

Thunberg, Carl Peter. (1975). *Flora Japonica: Sistens Plantas Insularum Japonicarum*. Reprint of 1784 edition. Oriole Editions, New York.

Thunberg, Carl Peter, et al. (1994). *C. P. Thunberg's Drawings of Japanese Plants: Icones Plantarum Japonicarum Thunbergii*. Maruzen Co. Ltd, Tokyo.

Watt, Alistair. (2017). *Robert Fortune: A Plant Hunter in the Orient*. Royal Botanic Gardens, Kew.

Willis, Kathy and Fry, Carolyn. (2014). *Plants from Roots to Riches*. John Murray, London in association with the Royal Botanic Gardens, Kew.

Yamanaka, Masumi and Rix, Martyn (2017). *Flora Japonica*, revised edition. Royal Botanic Gardens, Kew.

Online

www.biodiversitylibrary.org The world's largest open access digital library specialising in biodiversity and natural history literature and archives, including many rare books.

www.kew.org Royal Botanic Gardens, Kew website with information on Kew's science, collections and visitor programme.

www.plantsoftheworldonline.org An online database providing authoritative information of the world's flora gathered from the botanical literature published over the last 250 years.

INDEX

Royal Botanic Gardens Kew

First published in 2020
Royal Botanic Gardens, Kew,
Richmond, Surrey, TW9 3AB, UK
www.kew.org

ISBN 978 1 84246 720 6

Distributed on behalf of the Royal Botanic Gardens, Kew in North America by the University of Chicago Press, 1427 East 60th St, Chicago, IL 60637, USA.

British Library Cataloguing in Publication Data
A catalogue record for this book is available from the British Library

Design: Ocky Murray
Page layout: Culver Design
Image work: Christine Beard , Culver Design
Production Manager: Jo Pillai
Copy-editing: Michelle Payne

Printed and bound in Italy by Printer Trento srl.

Front cover image: *Lilium speciosum* (see page 86)

Endpapers: Washi (handmade Japanese paper) depicting blue ferns against a key-fret motif, from the Parkes Collection, Economic Botany Collection, Kew, 1871

p2: Grounds of the Hoshun-in Temple, Kyoto, from Josiah Conder *Landscape Gardening in Japan*, 1893

p4: Visiting the maples at Oji, from Josiah Conder *The Flowers of Japan and The Art of Floral Arrangement*, 1891

p10: *Wisteria floribunda*, Japanese wisteria, by Marianne North, from Marianne North Collection, Kew, 1880

For information or to purchase all Kew titles please visit shop.kew.org/kewbooksonline or email publishing@kew.org

Kew's mission is to be the global resource in plant and fungal knowledge and the world's leading botanic garden.

Kew receives approximately one third of its funding from Government through the Department for Environment, Food and Rural Affairs (Defra). All other funding needed to support Kew's vital work comes from members, foundations, donors and commercial activities, including book sales.

Publisher's note about names
The scientific names of the plants featured in this book are current, Kew accepted names at the time of going to press. They may differ from those used in original-source publications. The common names given are those most often used in the English language, or sometimes vernacular names used for the plants in their native countries.